T0039886

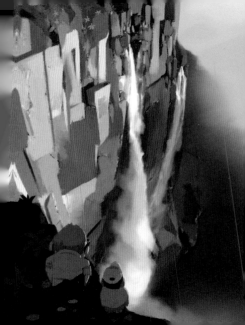

PIXAR

A MINIATURE
ART COLLECTION

BY BROOKE VITALE

INSIGHT
EDITIONS

San Rafael · Los Angeles · London

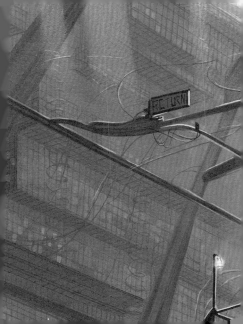

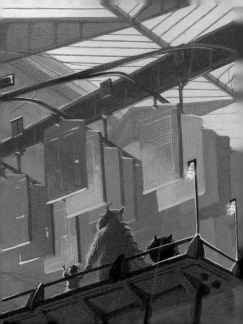

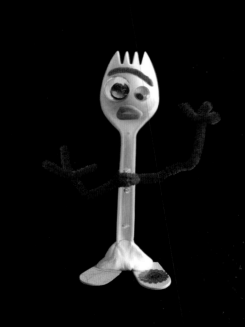

CONTENTS

INTRODUCTION 11

EARLY DAYS 16

1990s 39

2000s 69

2010s 151

2020s 273

CREDITS 290

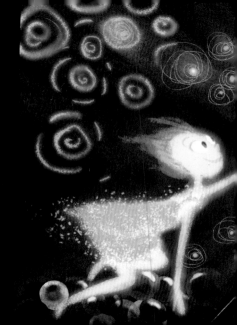

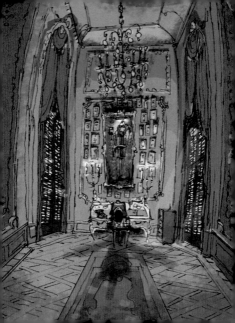

INTRODUCTION

Today, Pixar is known as one of the leading forces in computer animation and visual storytelling. The group that would eventually become Pixar began as a part of the Lucasfilm Computer Division. In 1979, computer scientist Ed Catmull joined the Computer Division there to head up a team focused on developing tools for advanced digital filmmaking. The company embraced this drive to create computer graphics, and

Catmull sought out like-minded artists, including former Disney animator John Lasseter. In 1986, Apple co-founder Steve Jobs purchased the computer graphics division from Lucasfilm. Under the direction of Catmull, Lasseter, and Jobs, the newly renamed Pixar focused on the hardware business, software business, and computer animation, setting their sights on creating the first entirely computer-animated feature film.

From the early days, to the release of *Toy Story*, to the next generation of animated films, Pixar has continually sought to reach new technological and artistic heights in the name of storytelling. In this miniature art book, fans will find a curated collection of art spanning the studio's extensive film library, from *Toy Story* to *Up*, to *Coco*, and beyond—a pocket-sized celebration of technology, artistry, and story.

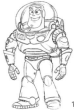

EARLY DAYS

From their earliest days, Pixar films offered a unique perspective that demonstrated the marriage of technology and artistic vision. While the Graphics Group was still under the ownership of Lucasfilm, they created the animated short *The Adventures of André & Wally B.*, which introduced the use of motion blur, complex backgrounds, and nongeometric shapes. Over the next five years, the studio continued to strive

to innovate. By the end of the decade, the newly independent Pixar had earned two Academy Award nominations and one win for the short film *Tin Toy*, the first-ever CGI film to win an Oscar. Although lesser known than Pixar's feature films, it was these early films that helped to bring legitimacy to CGI films as an art form and laid the groundwork for many of the films we see today.

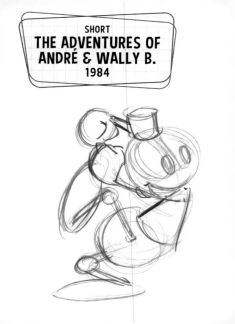

SHORT
THE ADVENTURES OF ANDRÉ & WALLY B.
1984

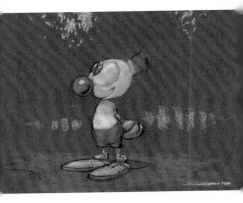

John Lasseter 1984

19

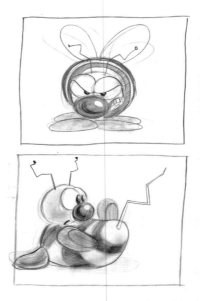

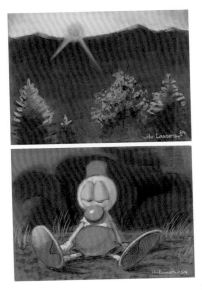

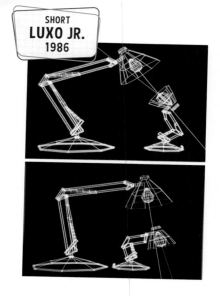

SHORT
LUXO JR.
1986

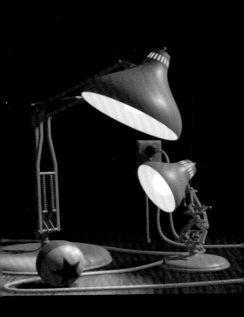

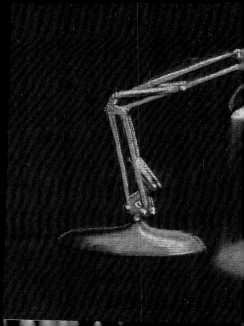

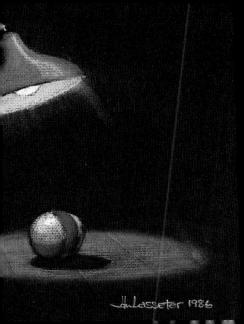

DESCRIPTION:		NOTES:	SEQUENCE/SHOT
THEN TO CAMERA			DS-12
ELEMENTS	DATE:		Sheet: 4
		FRAME COUNT:	PAGE: 46

Company Confidential

Pkg 3-1947

DESCRIPTION: END ON EXTERIOR OF EBEN'S BIKES.		**NOTES:** Use last shot of EB-1	**SEQUENCE/SHOT:** SE-4
ELEMENTS bstore	**DATE:**		**Sheet:**
		FRAME COUNT: 5 SEC/120 f	**PAGE#:** 62

DESCRIPTION: SLOWLY LEANS AGAINST WALL ...		**NOTES:**	**SEQUENCE/SHOT:** SE-3
ELEMENTS	**DATE:**		**Sheet:** 3
		FRAME COUNT:	**PAGE#:** 60

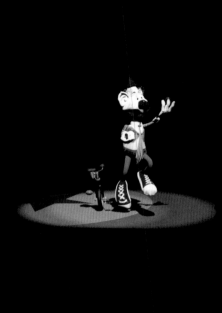

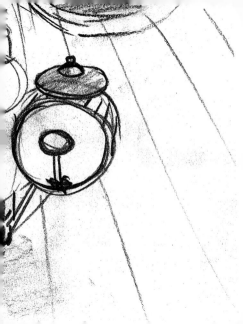

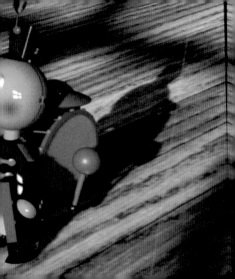

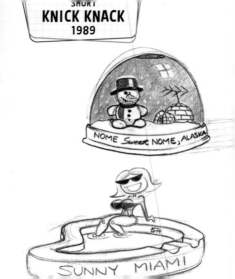

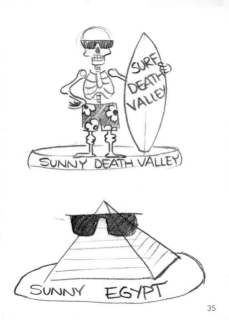

35

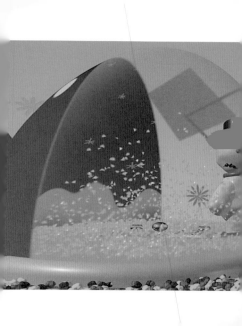

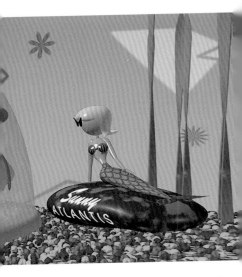

1990s

The 1990s saw the release of *Toy Story*, the first-ever fully computer-animated feature film, and a game changer for Pixar.

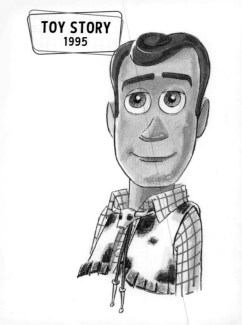

TOY STORY
1995

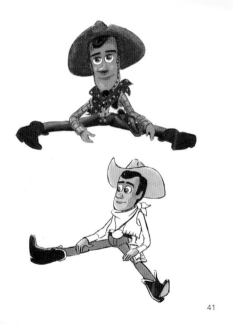

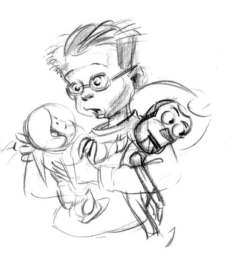

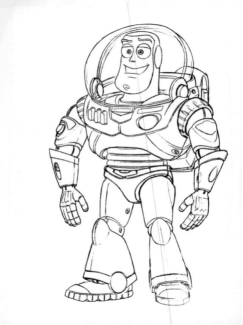

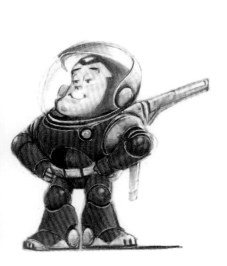

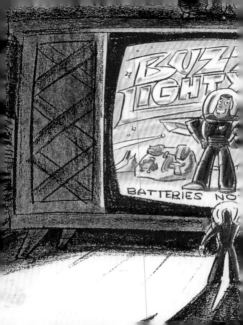

63

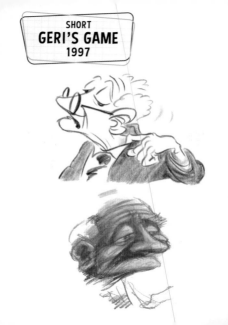

SHORT
GERI'S GAME
1997

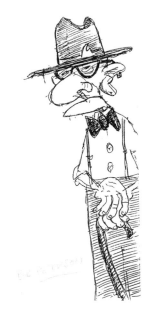

49

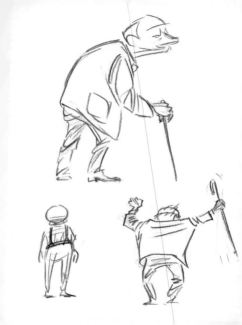

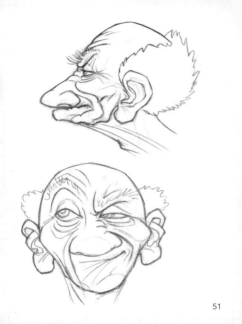

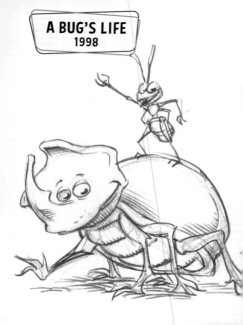

A BUG'S LIFE
1998

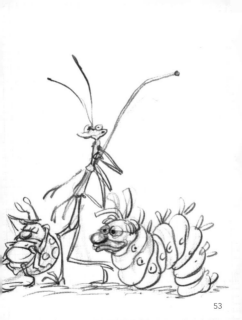

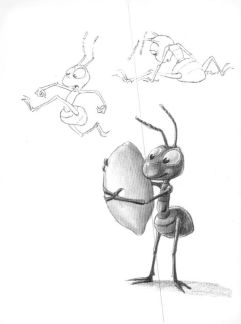

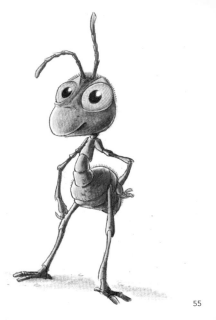

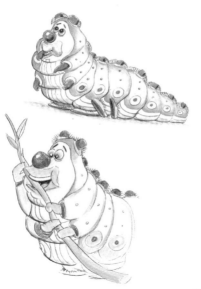

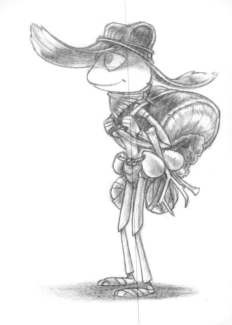

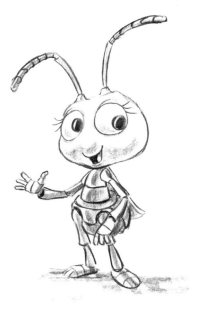

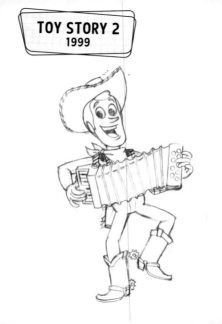

TOY STORY 2
1999

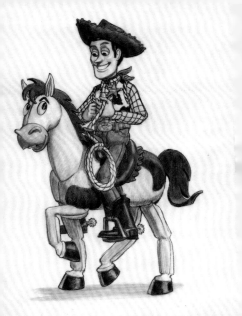

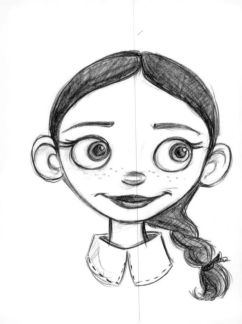

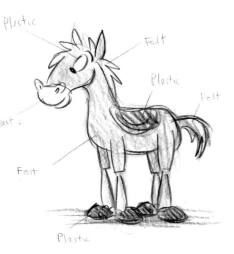

Plastic

Felt

Plastic

Felt

Felt

Felt

Plastic

63

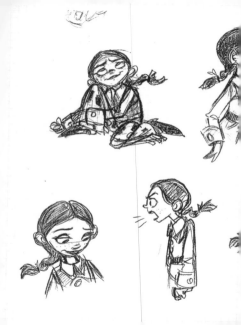

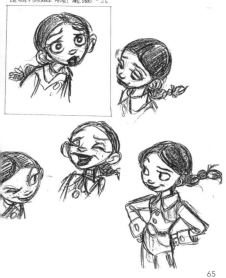

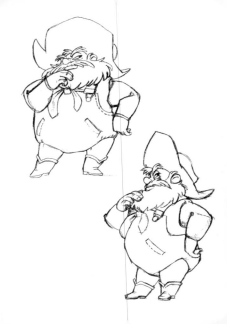

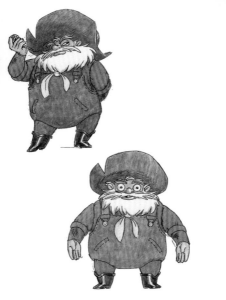

Pan der Beurtt 67

2000s

The 2000s was a time of continued innovation for Pixar. From developing methods that helped to make every hair on a monster's body properly lit to improving the realistic movement of fabric, the Pixar filmmakers brought their artistry to life with new techniques that are still used today by many across the film industry.

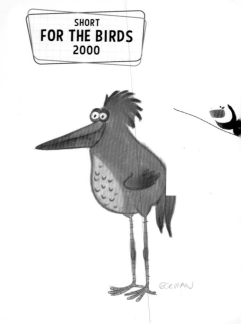

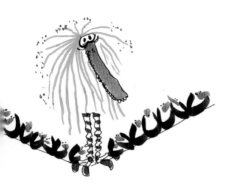

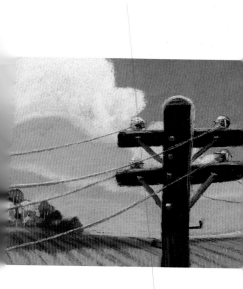

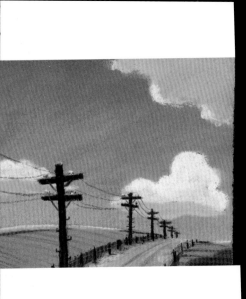

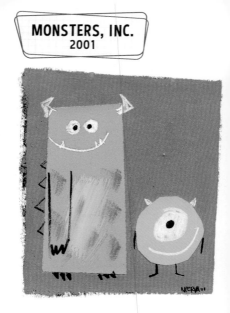

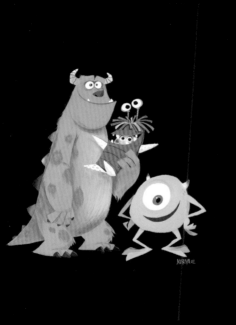

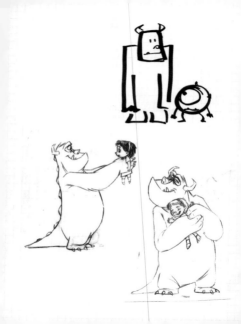

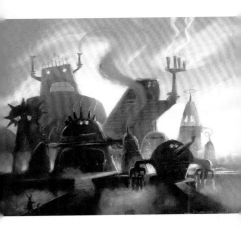

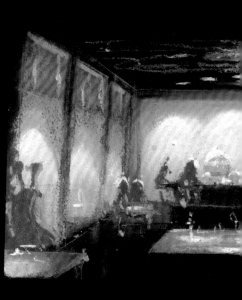

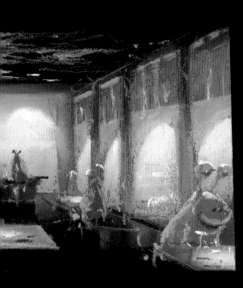

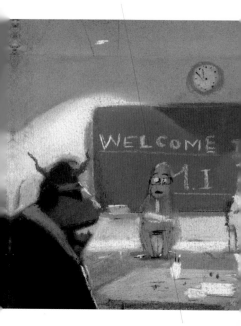

FINDING NEMO
2003

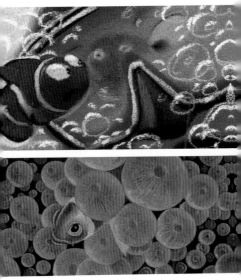

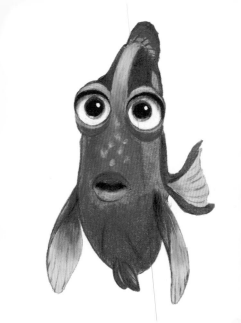

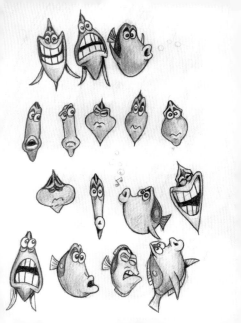

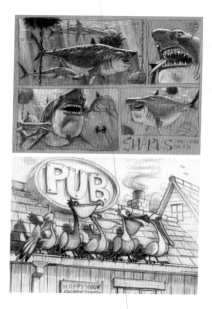

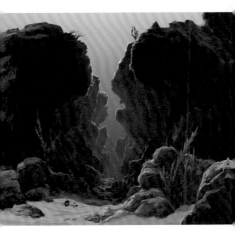

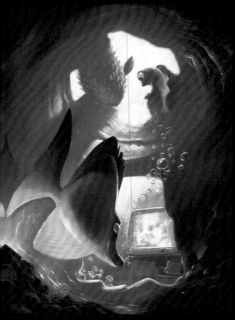

SHORT
BOUNDIN'
2003

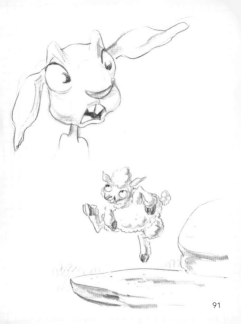

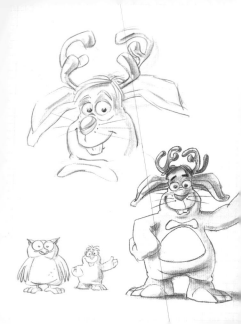

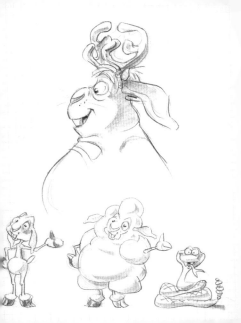

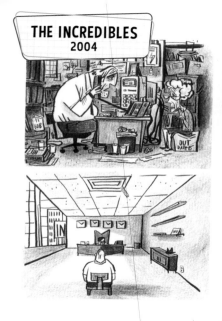

BOB CIRCA 1945

MR INCREDIBLE

AMERICA'S GOLDEN BOY

COSTUME STUDY

LOU OO

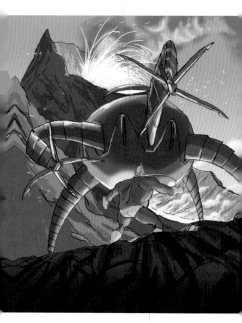

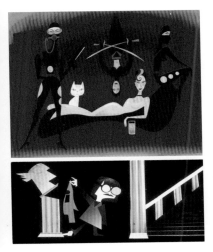

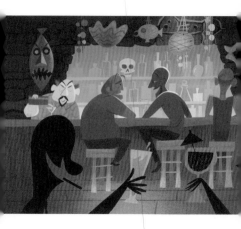

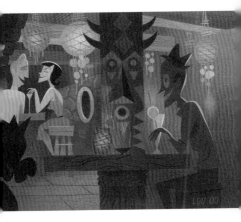

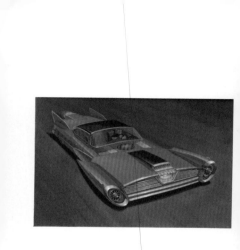

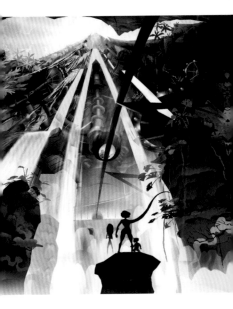

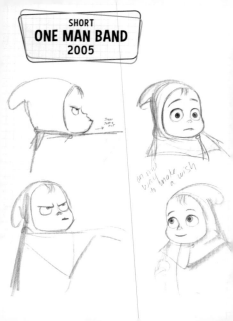

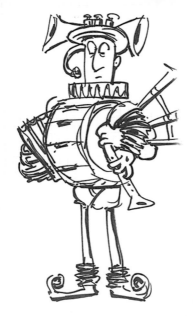

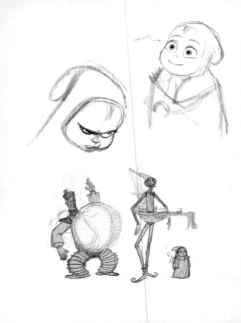

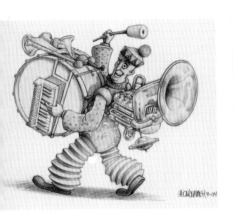

105

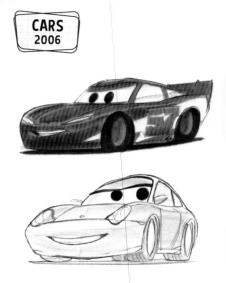

CARS
2006

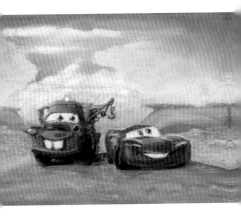

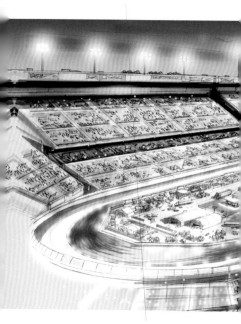

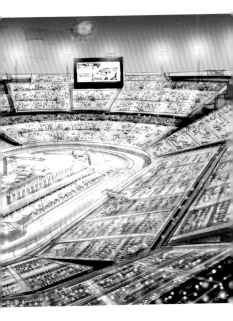

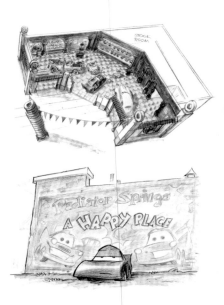

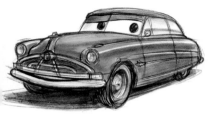

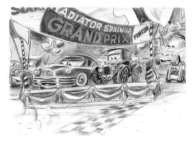

SHORT
LIFTED
2006

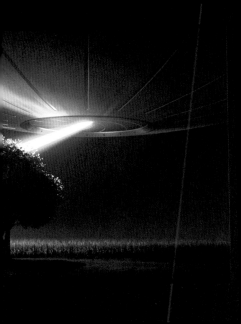

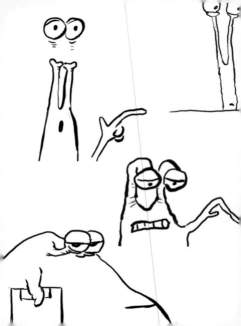

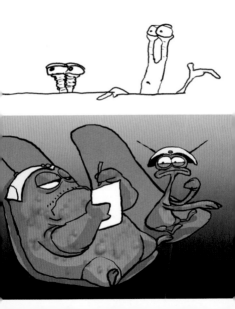

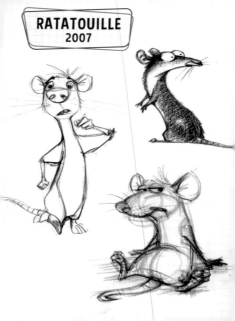

RATATOUILLE
2007

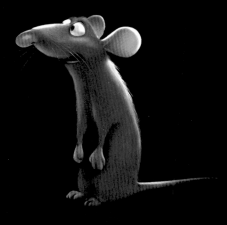

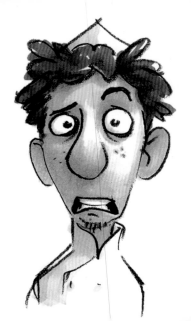

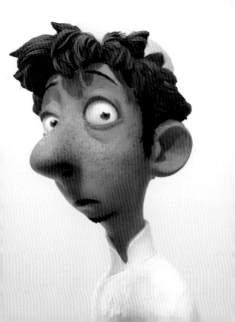

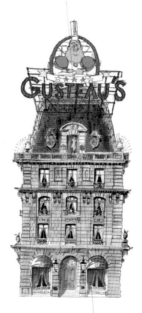

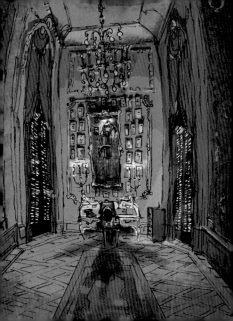

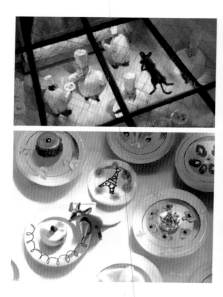

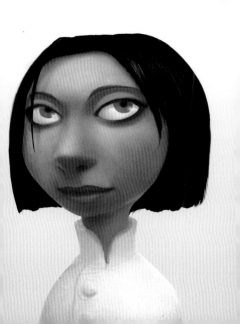

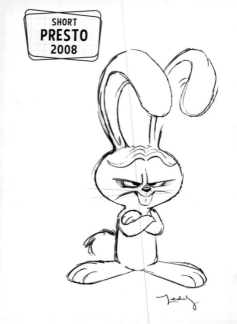

SHORT
PRESTO
2008

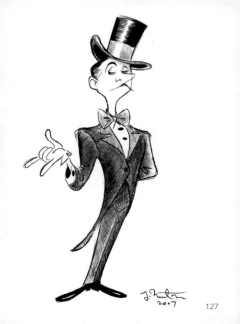

127

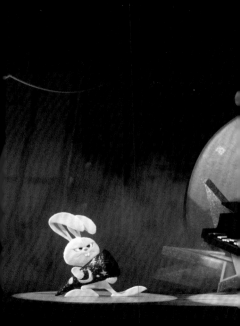

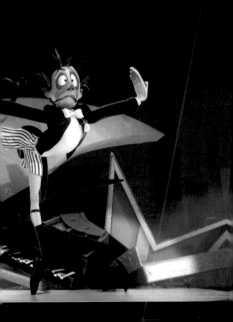

WALL-E
2008

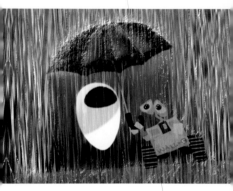

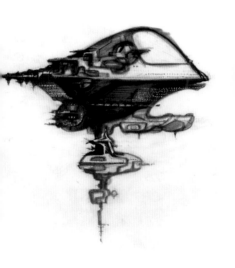

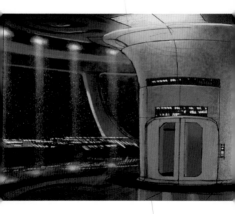

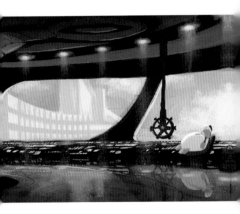

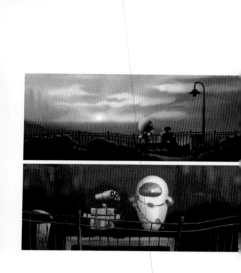

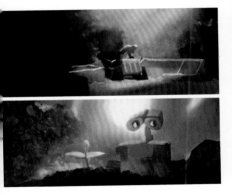

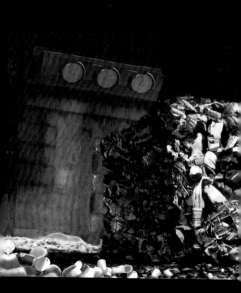

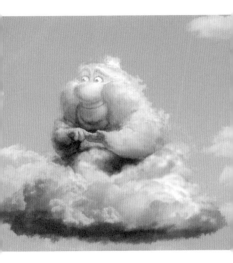

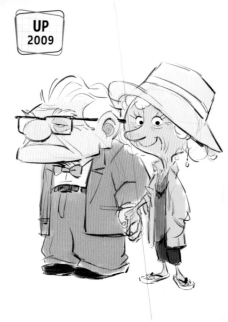

UP
2009

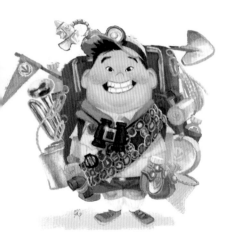

143

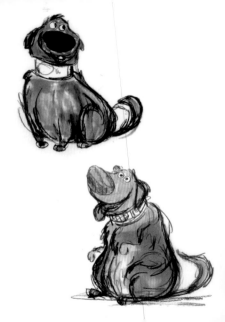

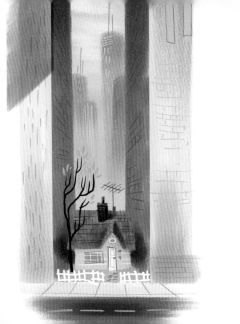

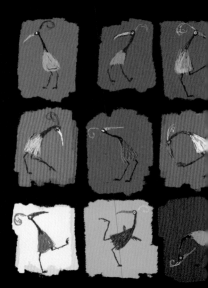

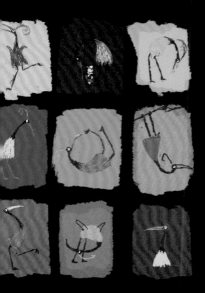

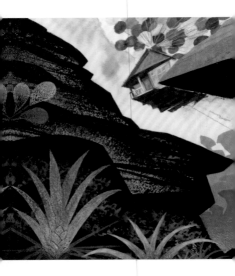

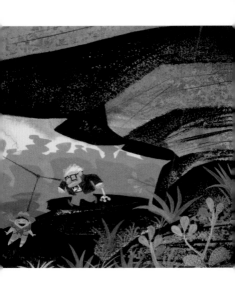

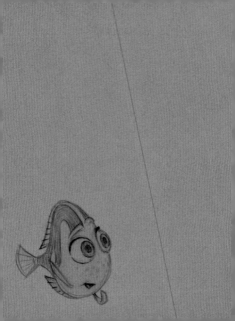

2010s

Pixar continued to deliver entertaining animated stories to a global audience. The 2010s took moviegoers on dazzling and far-reaching journeys, from the Highlands of Scotland to the realm of dinosaurs; from the Land of the Dead to our very own minds. The results have been an enthralling and wide-ranging collection of animated films.

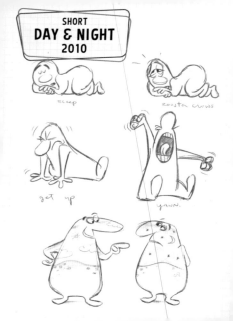

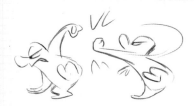

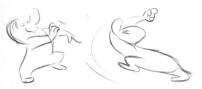

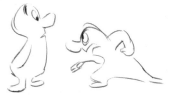

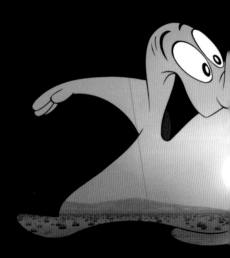

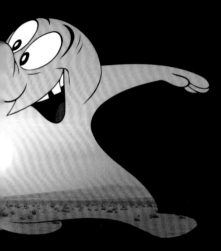

TOY STORY 3
2010

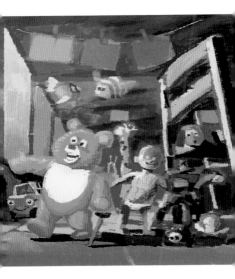

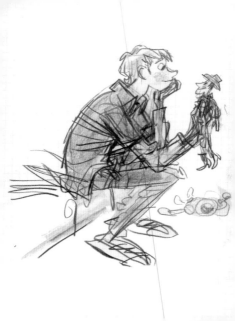

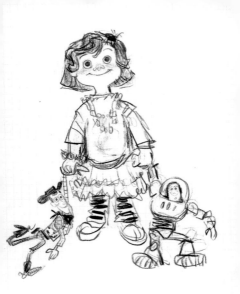

159

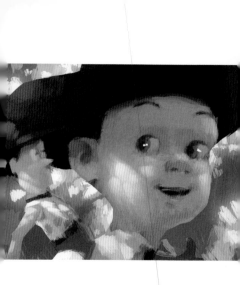

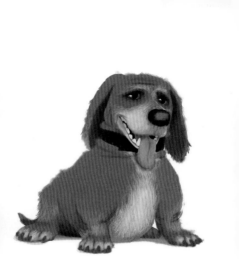

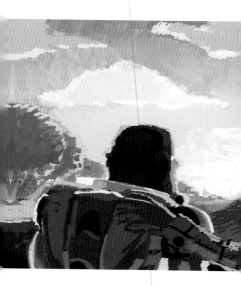

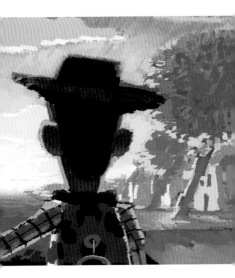

163

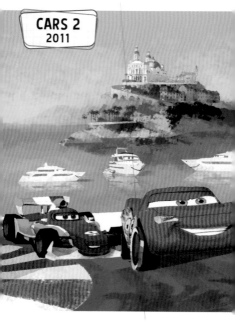

CARS 2
2011

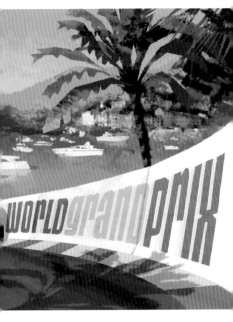

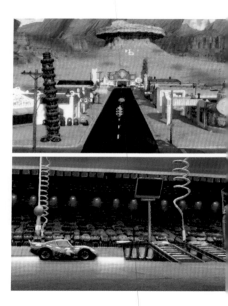

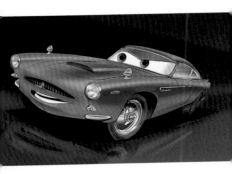

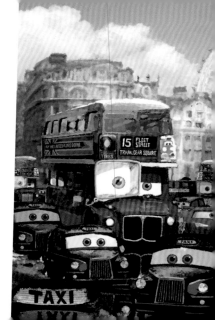

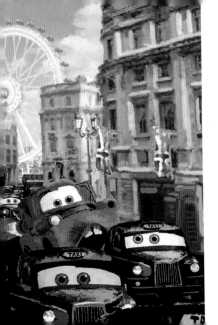

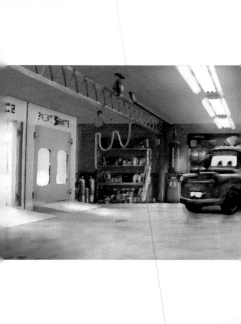

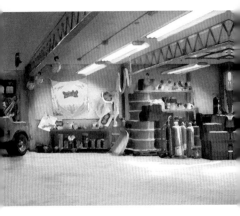

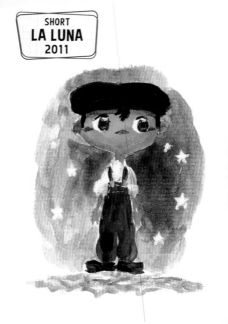

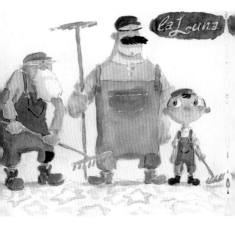

173

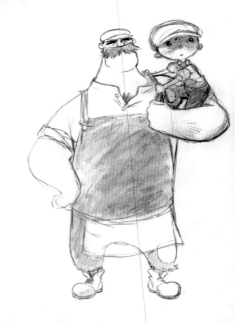

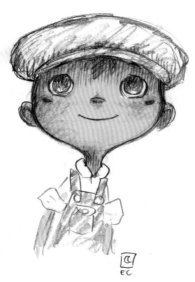

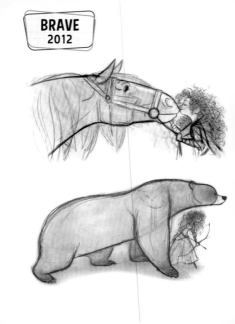

BRAVE
2012

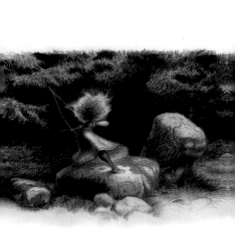

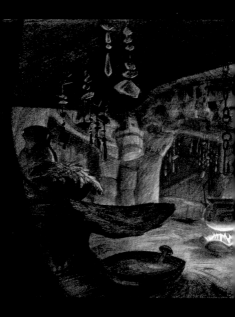

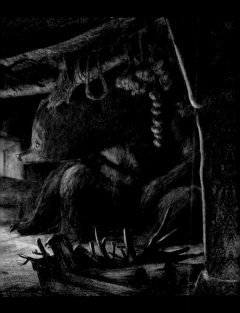

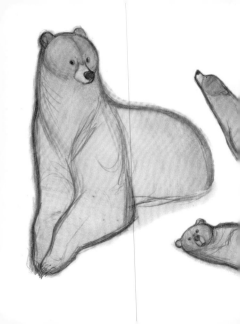

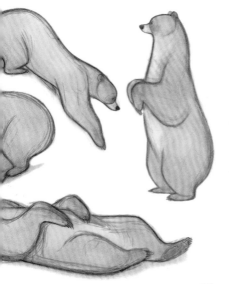

181

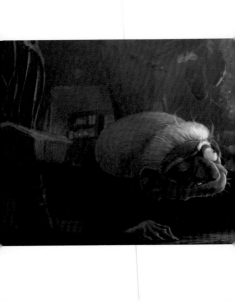

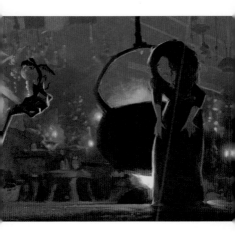

SHORT
THE BLUE UMBRELLA
2013

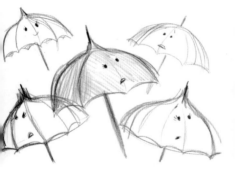

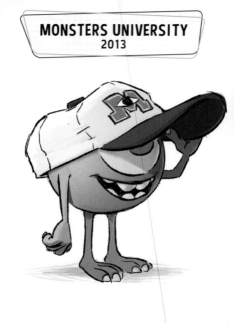

MONSTERS UNIVERSITY
2013

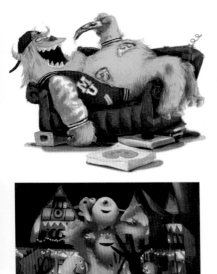

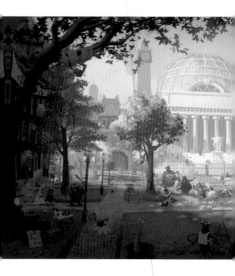

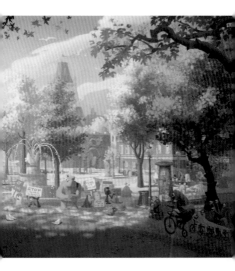

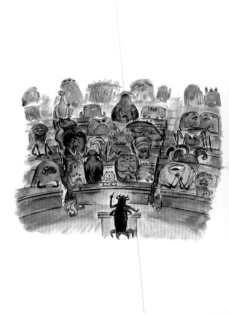

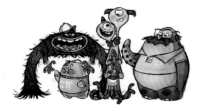

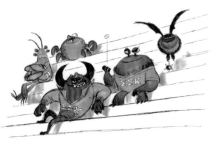

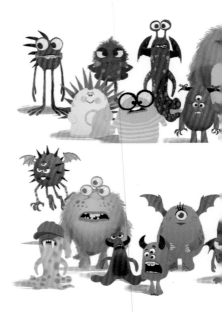

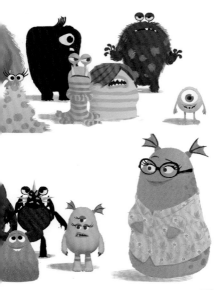

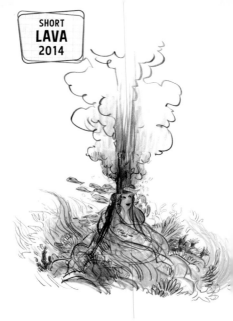

SHORT
LAVA
2014

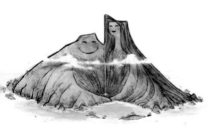

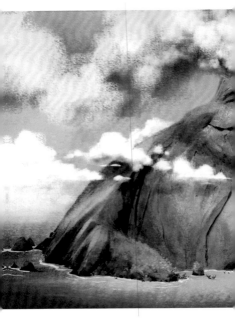

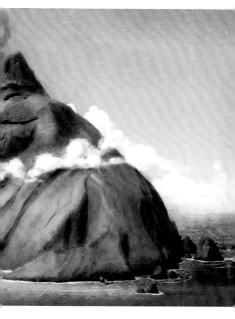

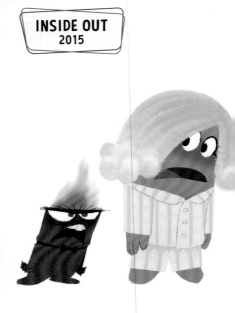

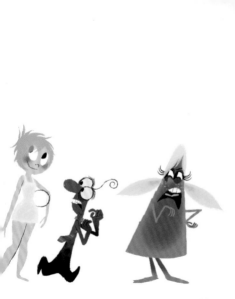

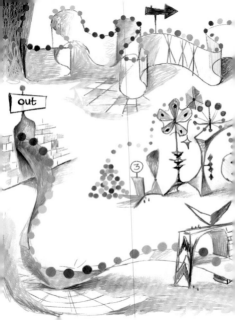

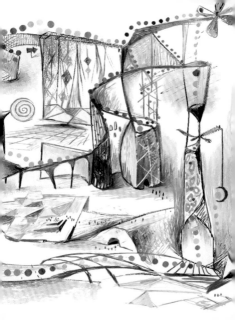

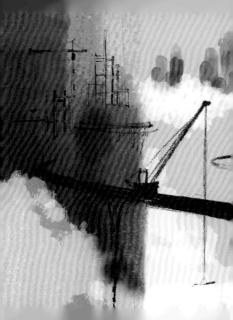

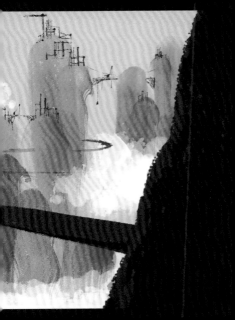

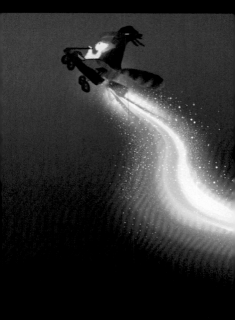

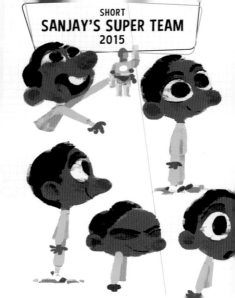

SHORT
SANJAY'S SUPER TEAM
2015

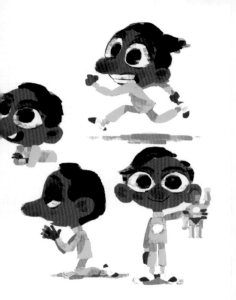

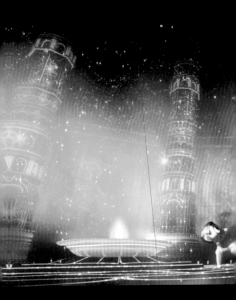

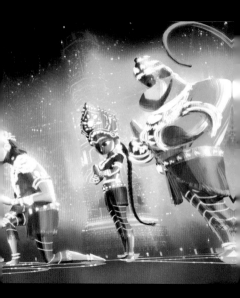

THE GOOD DINOSAUR
2015

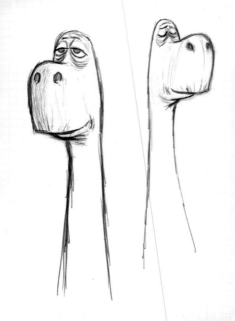

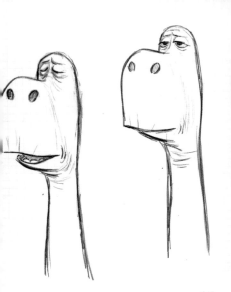

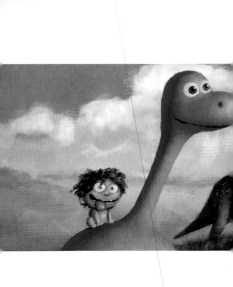

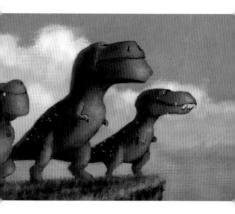

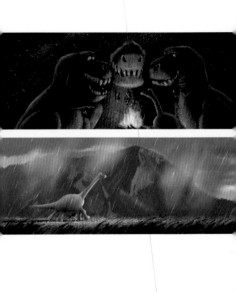

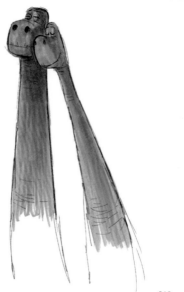

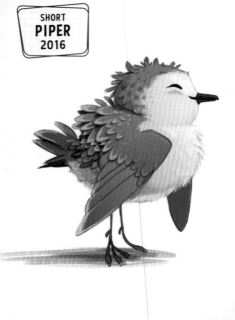

SHORT
PIPER
2016

fluff

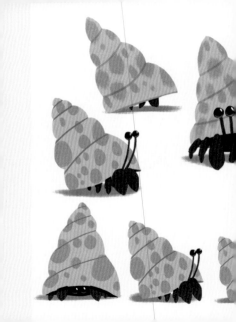

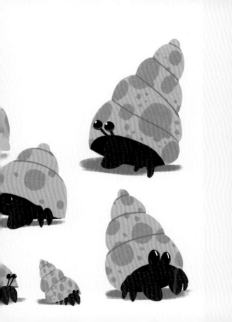

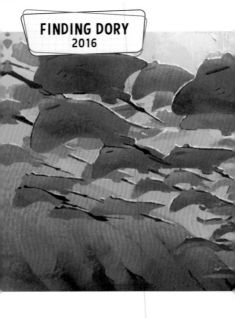

FINDING DORY
2016

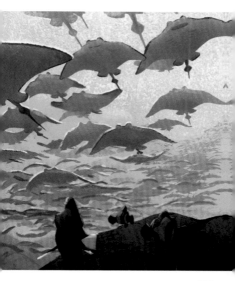

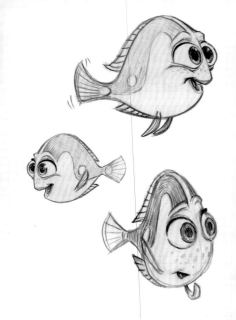

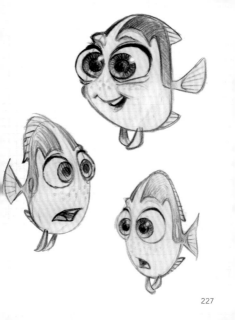

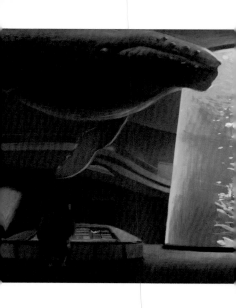

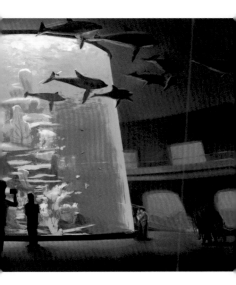

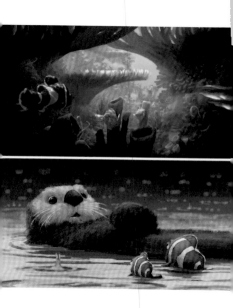

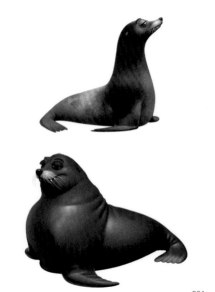

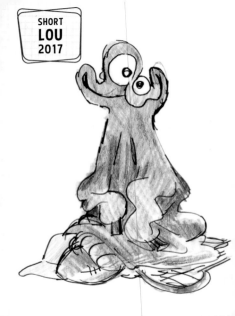

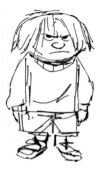

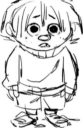

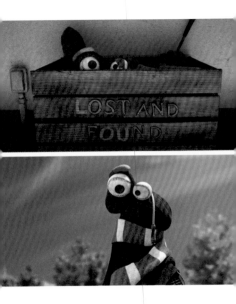

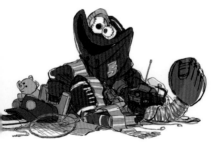

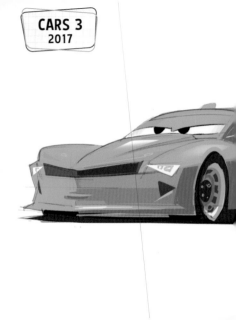

CARS 3
2017

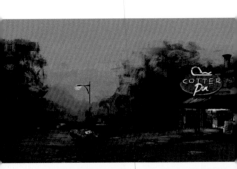

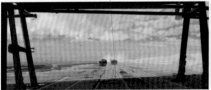

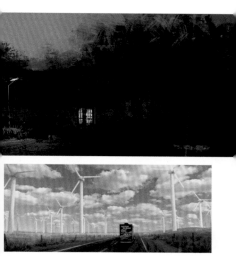

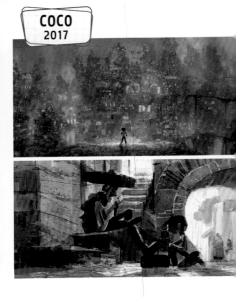

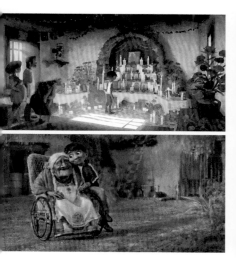

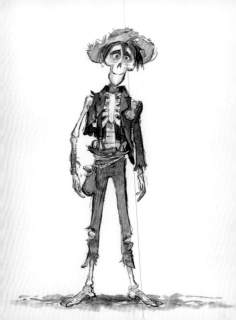

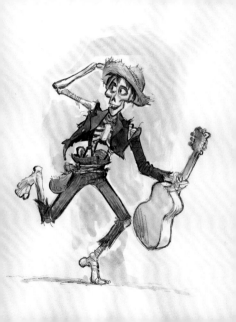

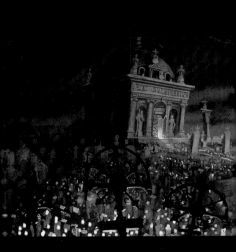

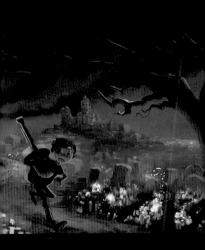

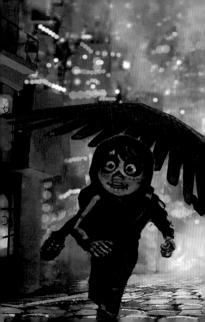

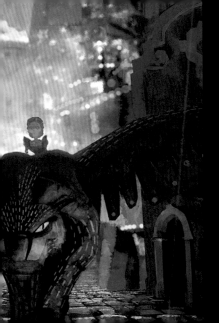

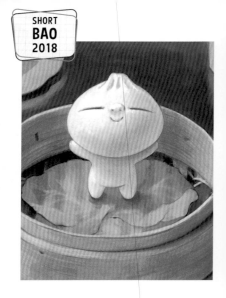

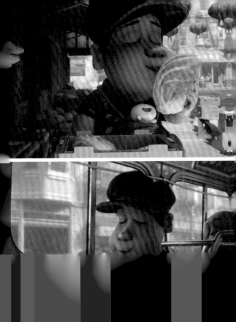

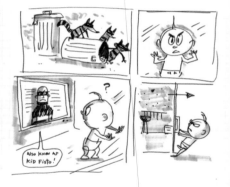

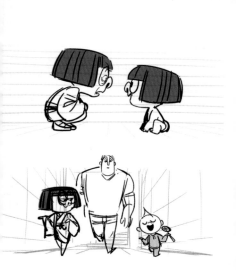

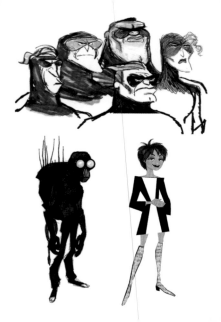

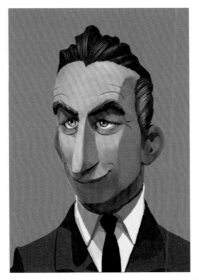

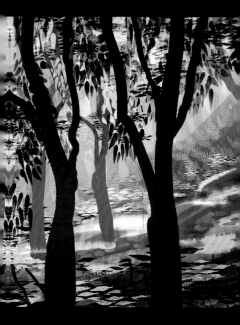

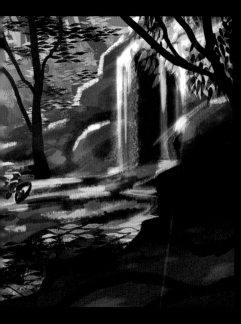

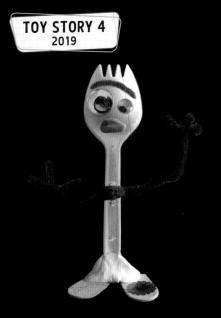

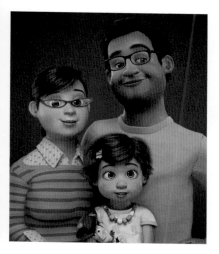

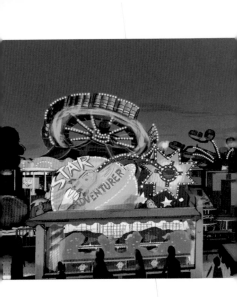

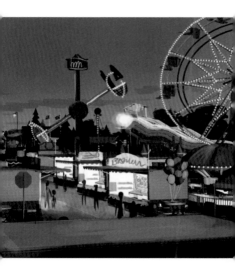

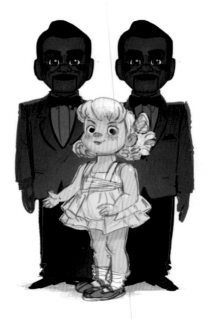

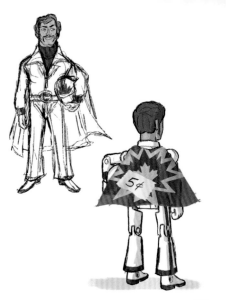

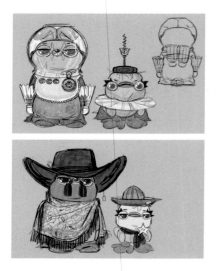

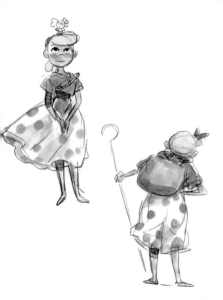

2020s

As the studio moves toward the future, there is little doubt that it will continue to push the envelope on the ways in which technology and art coexist. With every film the studio creates, Pixar demonstrates an enduring commitment to the creation of compelling, inventive, and ultimately transformative visual storytelling.

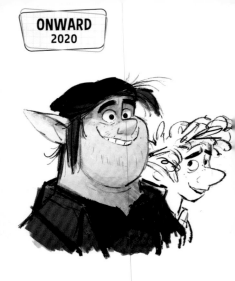

ONWARD
2020

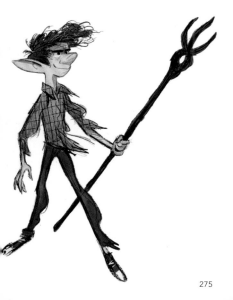

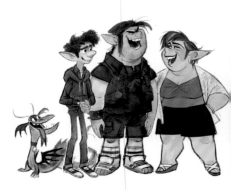

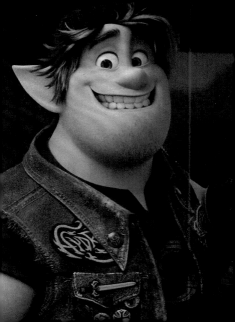

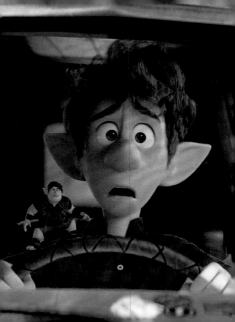

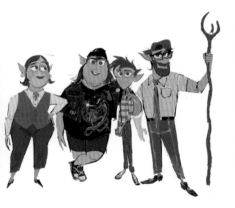

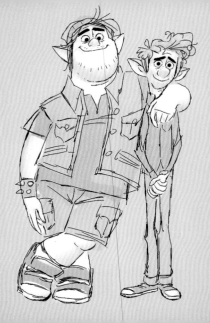

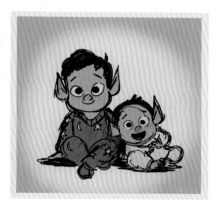

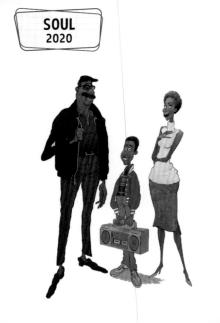

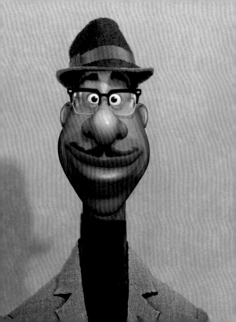

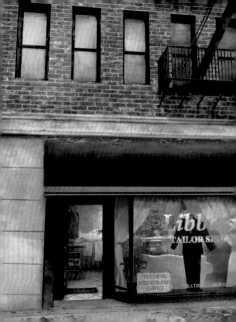

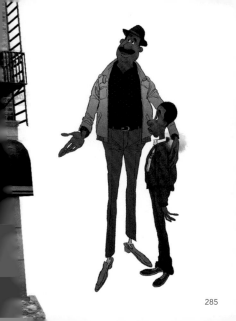

CREDITS

Page 48: Jan Pinkava, pencil; Jan Pinkava, crayon

Page 49: Bob Peterson, pen

Page 50: Jan Pinkava, pencil

Page 51: Jan Pinkava, pencil

Page 68: Dan Lee, pencil

Page 70: Ralph Eggleston, crayon

Page 71: Ralph Eggleston, marker

Pages 72–73: Ralph Eggleston, pastel

Page 74: Ricky Nierva, gouache

Page 75: Ricky Nierva, gouache

Page 76: Pete Doctor, marker; Dan Lee, pencil

Page 77: Dominique Louis, layout by Geefwee Boedoe, pastel

Pages 78–79: Dominique Louis, layout by Harley Jessup, pastel

Pages 80–81: Dominique Louis, pastel

Page 82: Dan Lee, pencil

Page 83: Ralph Eggleston, pastel; August Hall, acrylic

Page 84: Ralph Eggleston, pastel and marker

Page 85: Brett Coderre, color pencil

Page 86: James S. Baker, color pencil and wash; Jason Deamer, pencil, color pencil, and marker

Page 87: Randy Berrett, digital

Page 88: Dominique Louis, layout by Nelson Bohol, pastel

Page 89: Ralph Eggleston, pastel

Pages 90–91: Bud Luckey, pencil

Pages 92–93: Bud Luckey, pencil

Page 94: Lou Romano, pencil and marker

Page 95: Lou Romano, gouache

Page 96: Mark Andrews, digital

Page 97: Lou Romano, gouache; Teddy Newton, collage

Pages 98–99: Lou Romano, gouache

Page 100: John Lee, layout by Scott Caple, acrylic

Page 101: Glen Kim, digital

Page 102: Ronnie del Carmen, pencil

Page 103: Mark Andrews, marker

Page 104: Ronnie del Carmen, pencil; Ronnie del Carmen, pencil and Photoshop

Page 106: Bob Pauley, mixed media; Bob Pauley, pencil

Pages 108–109: Jay Shuster, pencil and marker

Page 110: Bud Luckey, pencil; Steve Purcell, ink and pencil

Page 111: Bob Pauley, pencil and marker; Bud Luckey, pencil

Pages 112–113: Tia Kratter, acrylic

Page 118: Dan Lee, pencil; Peter DeSeve, pencil; Jason Deamer, pencil

Page 119: Dominique Louis, shading study

Page 120: Jason Deamer, pencil and marker

Page 121: Robert Kondo, digital paint over sculpt by Greg Dykstra

Page 122: Harley Jessup, pencil and marker

Page 124: Dominique Louis, layout by Harley Jessup, pastel; Dominique Louis, layout by Harley Jessup, digital

Page 125: Belinda Van Valkenburg and Robert Kondo, digital paint over sculpt by Greg Dykstra

Page 130: Ralph Eggleston, digital

Page 131: Nelson Bohol, pen and marker

Pages 132–133: John Lee, layout by Jay Shuster, digital

Page 134: John Lee, digital

Page 135: John Lee, digital

Pages 136–137: John Lee, digital

Page 142: Tony Fucile, digital

Page 143: Daniel López Muñoz, digital

Page 144: Albert Lozano, pencil/digital paint

Page 145: Don Shank, digital

Pages 146–147: Albert Lozano, digital

Pages 148–149: Ricky Nierva, gouache

Pages 156–157: Robert Kondo, layout by Bob Pauley, digital

Page 158: Tom Gately, pencil

Page 159: Tom Gately, pencil

Page 160: Dice Tsutsumi, digital

Page 161: Daniel Arriaga, digital

Pages 162–163: Robert Kondo, digital

Pages 164–165: Harley Jessup, digital

Page 166: Sharon Calahan, digital paint over set render

Page 167: Jay Shuster, color by Jack Chang, digital; Sharon Calahan, digital paint over set render

Pages 168–169: Harley Jessup, digital

Page 176: Matt Nolte, pencil

Page 177: Steve Pilcher, pencil

Pages 178–179: Louis Gonzales, pencil

Pages 180–181: Matt Nolte, pencil

Pages 182–183: Huy Nguyen, digital

Page 188: Jason Deamer, digital

Page 189: Ricky Nierva, digital; Shelly Wan, digital

Pages 190–191: Shelly Wan, digital

Page 192: Daniela Strijleva, pen and watercolor

Page 193: Daniela Strijleva, marker; Chris Sasaki, pencil

Pages 194–195: Jason Deamer, digital

Pages 200–201: Chris Sasaki, digital painting

Pages 202–203: Don Shank, colored pencil

Pages 204–205: Dan Holland, watercolor and digital painting

Pages 206–207: Chris Sasaki, digital painting

Pages 212–213: Kyle Macnaughton

Pages 214–215: Daniela Strijleva

Pages 216–217: Sharon Calahan

Page 218: Sharon Calahan, layout by Ricky Nierva; Eric Benson

Page 219: Daniela Strijleva

Pages 224–225: Rona Liu, digital painting

Pages 226–227: Jason Deamer, pencil

Pages 228–229: John Lee, layout by Tim Evatt, digital painting

Page 230: Shelly Wan, digital painting; Rona Liu and Sharon Calahan, digital painting

Page 231: Steve Pilcher, digital painting

Pages 236–237: Jay Shuster, digital

Pages 238–239: Kristian Norielus, digital

Pages 240–241: Noah Klocek, digital

Pages 242–243: Drew Hartel, digital; Bill Cone, digital; Paul Abadilla, digital

Page 244: Huy Nguyen, layout by Xavier Riffault and Dean Kelly, digital

Page 245: Shelly Wan, layout by Manny Hernandez, digital; Sharon Calahan, digital

Pages 246–247: Daniela Strijleva, pen and gouache

Pages 248–249: Armand Baltazar and John Nevarez, digital

Pages 250–251: Harley Jessup, digital

Pages 256–257: Ralph Eggleston, digital

Page 258: Teddy Newton, pencil

Page 259: Domee Shi, digital

Page 260: Matt Nolte, marker; Matt Nolte, pencil and digital; Bryn Imagire, digital

Page 261: Bryn Imagire, clay sculpt by Greg Dykstra, digital painting

Pages 262–263: Ralph Eggleston, digital

Page 265: Laura Phillips, digital painting

Pages 266–267: Nathaniel McLaughlin, digital

Page 268: Jason Deamer, digital

Page 269: Albert Lozano, digital

Page 270: Deanna Marsigliese, digital

Page 271: Michael Yates, pencil and watercolor

Page 282: Grant Alexander and Daniel López Muñoz, digital

Page 283: Daniel López Muñoz, digital

Page 284: Ernesto Nemesio, digital

Page 285: Grant Alexander, digital

Page 286: Ricky Nierva and Steve Pilcher, digital

Page 287: Bryn Imagire, digital

Page 288: Daniel López Muñoz, digital

Page 289: Daniel López Muñoz, digital

Pages 300–301: Jason Deamer, digital painting

Pages 302–303: Zaruhi Galystan, digital

Page 304: Tony Fucile and Teddy Newton, pencil and marker

All other pages: Courtesy Disney/Pixar

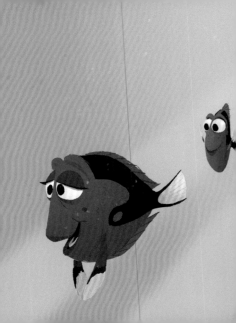

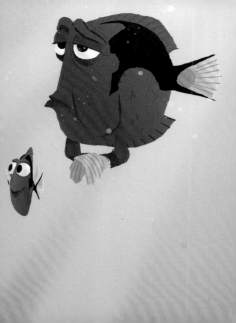

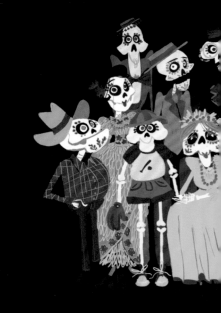

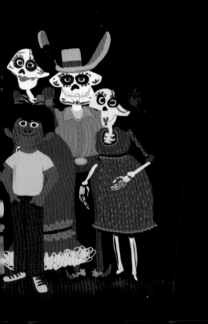